MAJESTIC EXPRESSIONS

Relax. Refresh. Renew

Be Still and Color

INSPIRATIONAL ADULT
COLORING BOOK

BroadStreet
P U B L I S H I N G

THIS
BOOK
BELONGS
TO

BroadStreet Publishing Group LLC
Racine, Wisconsin, USA
Broadstreetpublishing.com

MAJESTIC EXPRESSIONS

ᛒE STILL AND COLOR

© 2016 by BroadStreet Publishing

ISBN 978-1-4245-5163-7

Scripture quotations marked (NLT) are taken from the Holy Bible, New Living Translation, copyright © 1996, 2004, 2007. Used by permission of Tyndale House Publishers, Inc., Carol Stream, Illinois 60188. All rights reserved. Scripture quotations marked (NIV) are taken from the Holy Bible, New International Version®, NIV®. Copyright © 1973, 1978, 1984, 2011 by Biblica, Inc.™ Used by permission of Zondervan. All rights reserved worldwide. www.zondervan.com. The "NIV" and "New International Version" are trademarks registered in the United States Patent and Trademark Office by Biblica, Inc.™ Scripture quotations marked (NCV) are taken from the New Century Version®. Copyright © 2005 by Thomas Nelson. Used by permission. Scripture quotations marked (NASB) are taken from the New American Standard Bible®, Copyright © 1960, 1962, 1963, 1968, 1971, 1972, 1973, 1975, 1977, 1995 by The Lockman Foundation. Used by permission. www. Lockman.org. Scripture quotations marked (NRSV) are taken from the New Revised Standard Version Bible, copyright 1989, Division of Christian Education of the National Council of the Churches of Christ in the United States of America. Used by permission. All rights reserved. Scripture quotations marked (ESV) are from the ESV® Bible (The Holy Bible, English Standard Version®), copyright © 2001 by Crossway, a publishing ministry of Good News Publishers. Used by permission. All rights reserved. Scripture quotations marked HCSB®, are taken from the Holman Christian Standard Bible®, Copyright © 1999, 2000, 2002, 2003, 2009 by Holman Bible Publishers. Used by permission. HCSB® is a federally registered trademark of Holman Bible Publishers.

Cover design by Chris Garborg | garborgdesign.com
Compiled and edited by Michelle Winger | literallyprecise.com

Printed in the United States of America.

16 17 18 19 20 21 22 7 6 5 4 3 2 1

INTRODUCTION

There is plenty of research that shows coloring to be an effective stress reducer. Maybe you picked up this book because you've heard the hype and you're curious. Perhaps you've been looking for a way to relax. Now you have your very own adult coloring book, and you have every reason you need to sit down and color. And perforated pages make it easy for you to frame your favorites!

Coloring is a great distraction from all you have going on, but the best way to find lasting peace is to spend time with your Creator. Fill these intricately designed illustrations with the beauty of color as you dwell on the richness of his Word, the faithfulness of his character, and the depth of his love for you.

Happy coloring!

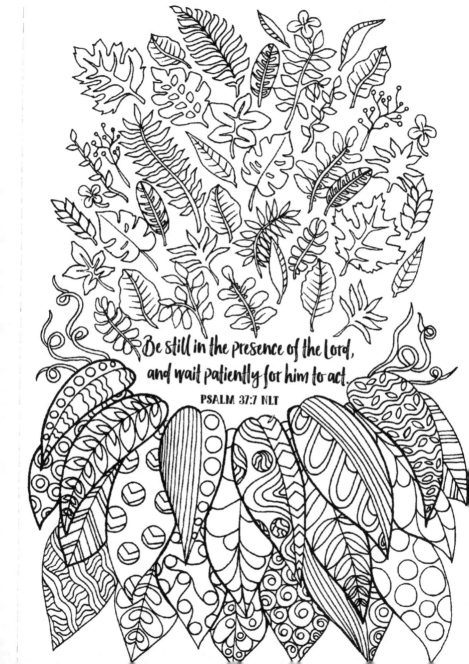

Be still in the presence of the Lord, and wait patiently for him to act.

PSALM 37:7 NLT

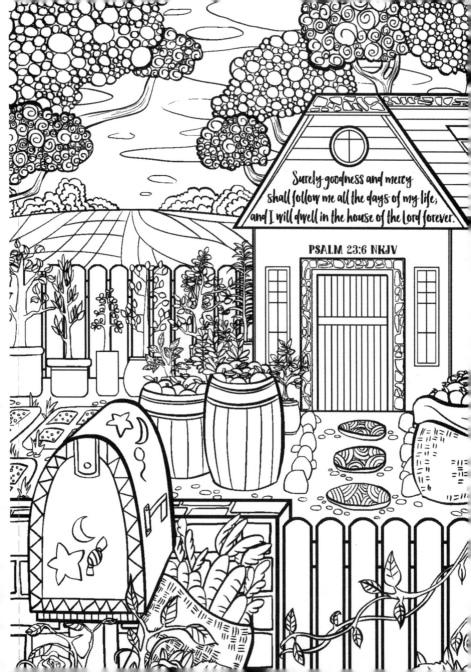

Surely goodness and mercy shall follow me all the days of my life; and I will dwell in the house of the Lord forever.

PSALM 23:6 NKJV

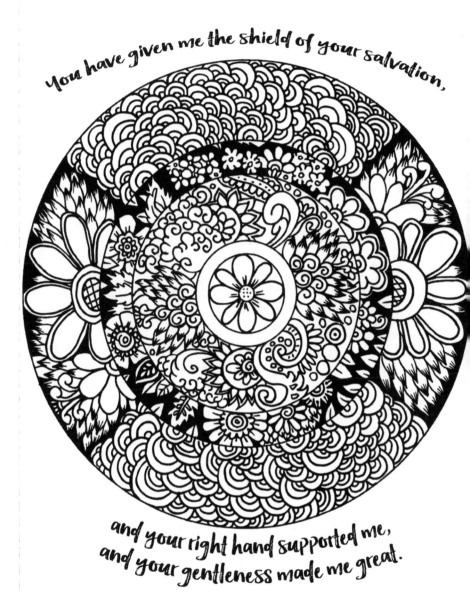

You have given me the shield of your salvation,

and your right hand supported me,
and your gentleness made me great.

PSALM 18:35 ESV

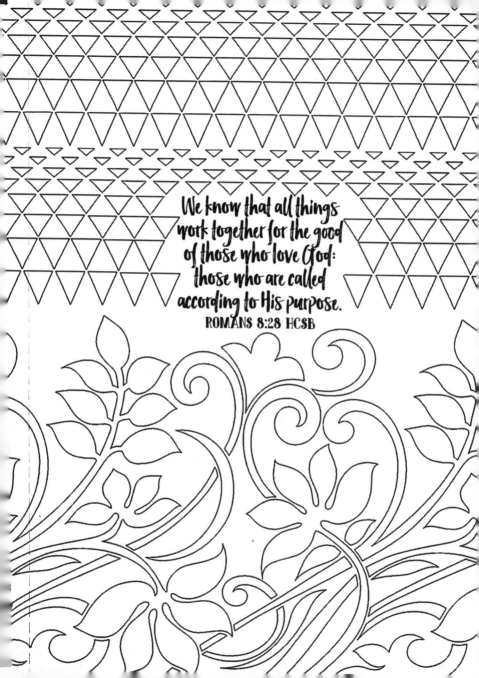

We know that all things
work together for the good
of those who love God:
those who are called
according to His purpose.
ROMANS 8:28 HCSB

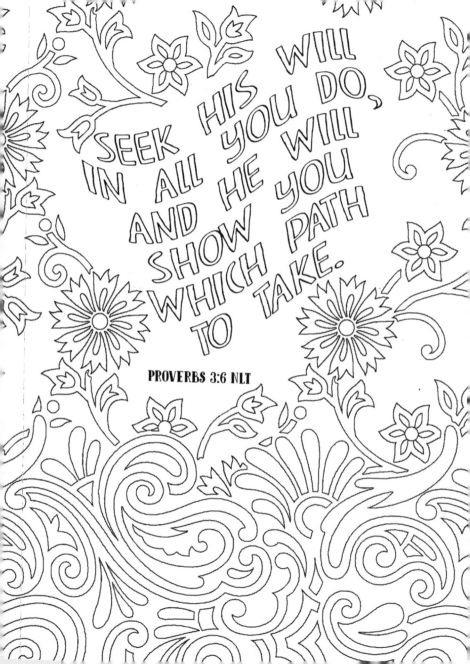

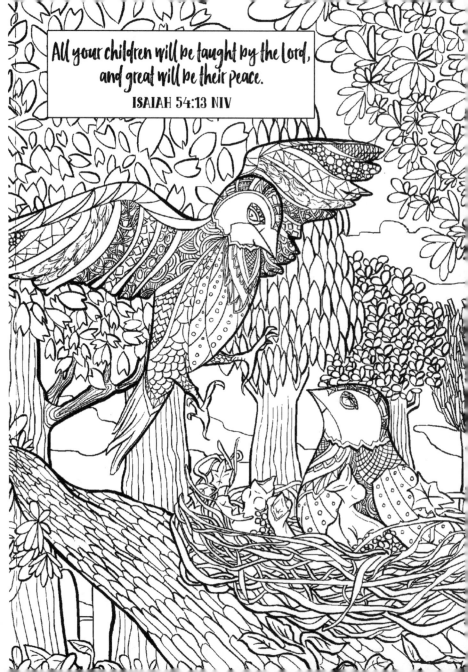

All your children will be taught by the Lord, and great will be their peace.

ISAIAH 54:13 NIV

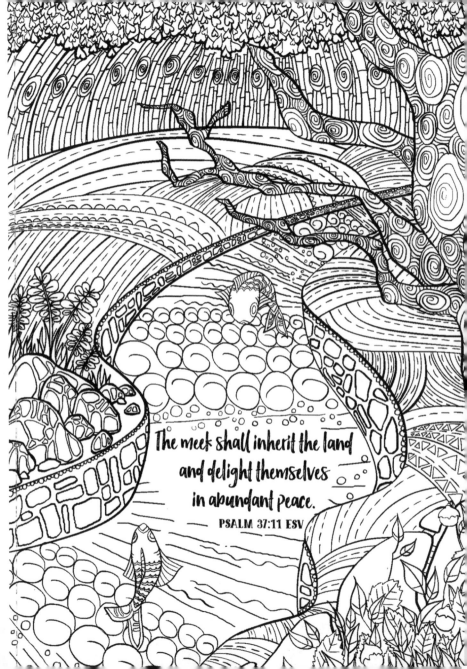

The meek shall inherit the land and delight themselves in abundant peace.

PSALM 37:11 ESV

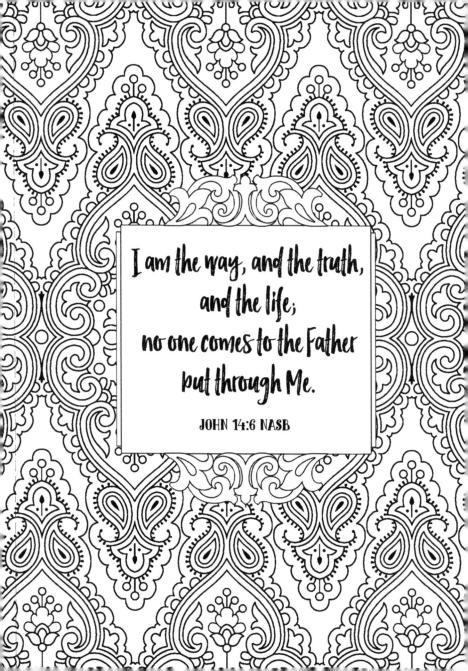

I am the way, and the truth, and the life; no one comes to the Father but through Me.

JOHN 14:6 NASB

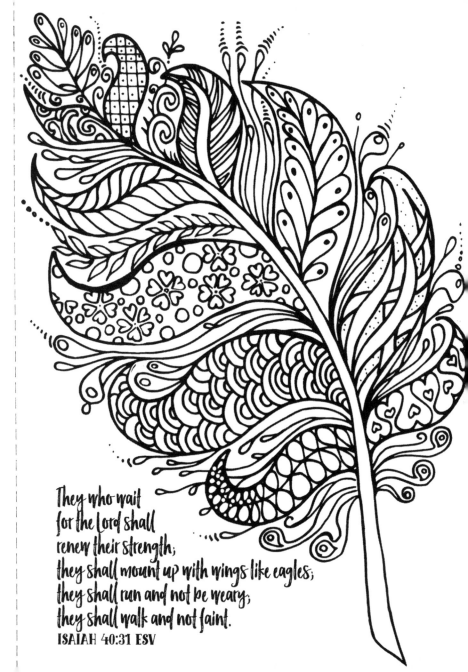

They who wait
for the Lord shall
renew their strength;
they shall mount up with wings like eagles;
they shall run and not be weary;
they shall walk and not faint.
ISAIAH 40:31 ESV

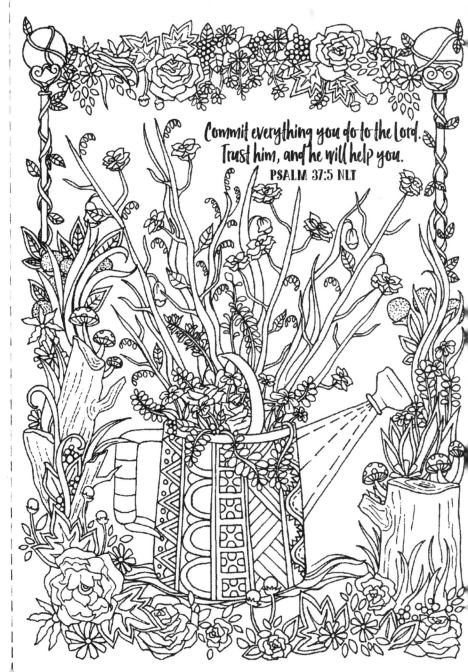

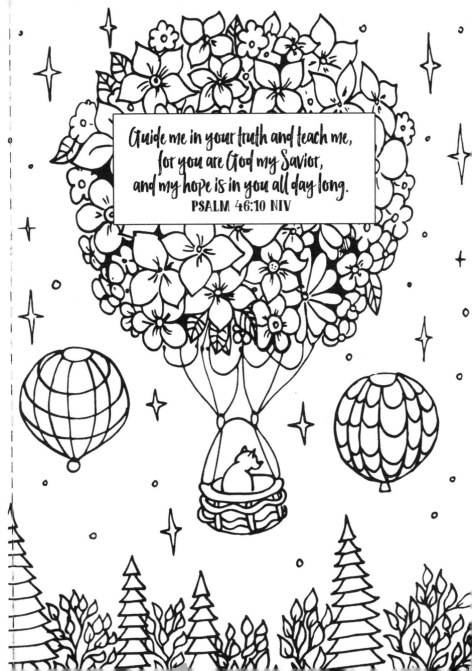

Guide me in your truth and teach me,
for you are God my Savior,
and my hope is in you all day long.
PSALM 46:10 NIV

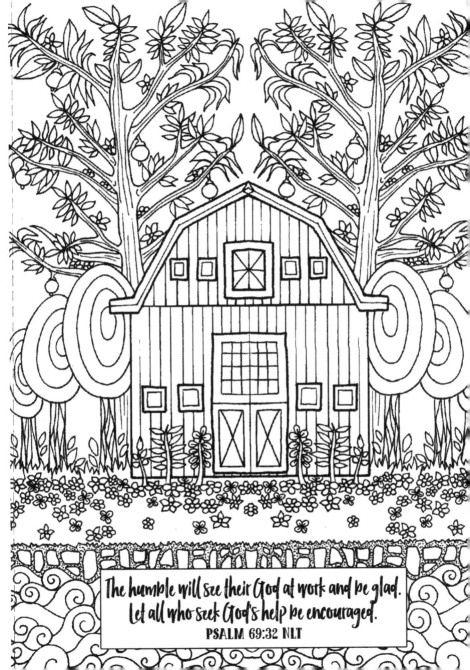

The humble will see their God at work and be glad.
Let all who seek God's help be encouraged.
PSALM 69:32 NLT

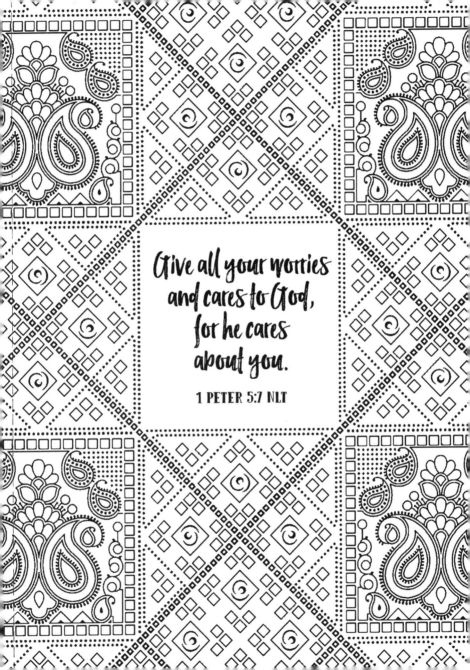

Give all your worries
and cares to God,
for he cares
about you.

1 PETER 5:7 NLT

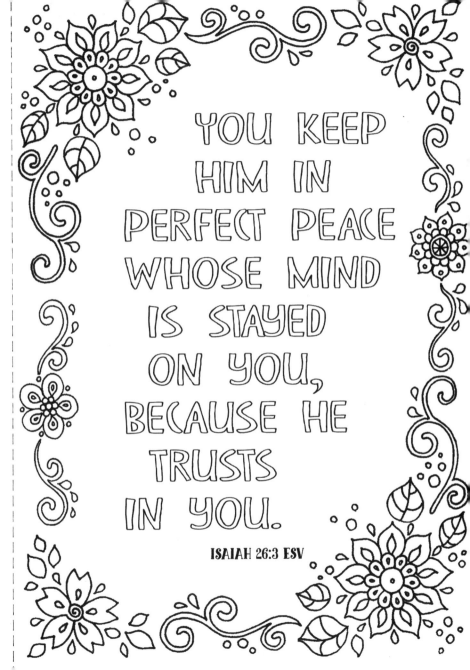

YOU KEEP HIM IN PERFECT PEACE WHOSE MIND IS STAYED ON YOU, BECAUSE HE TRUSTS IN YOU.

ISAIAH 26:3 ESV

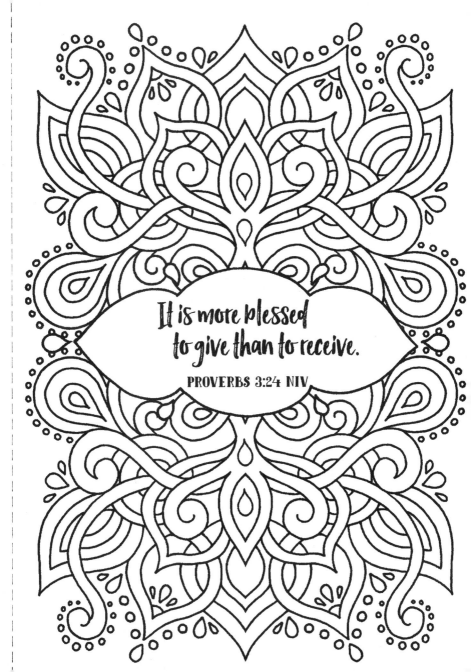

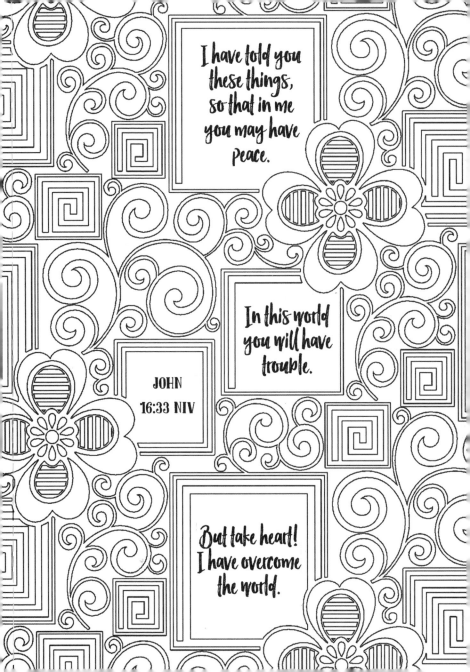

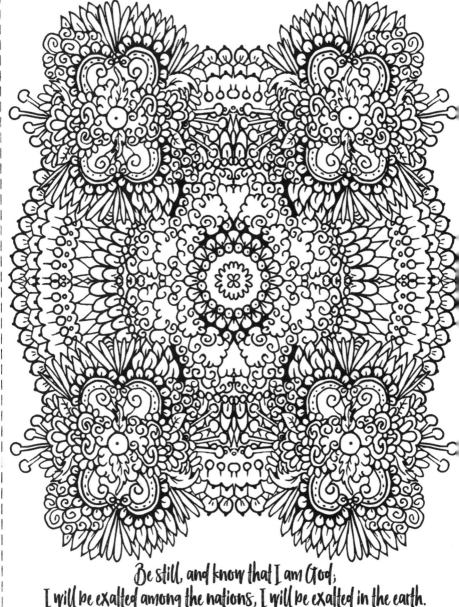

Be still, and know that I am God;
I will be exalted among the nations, I will be exalted in the earth.
PSALM 46:10 NIV

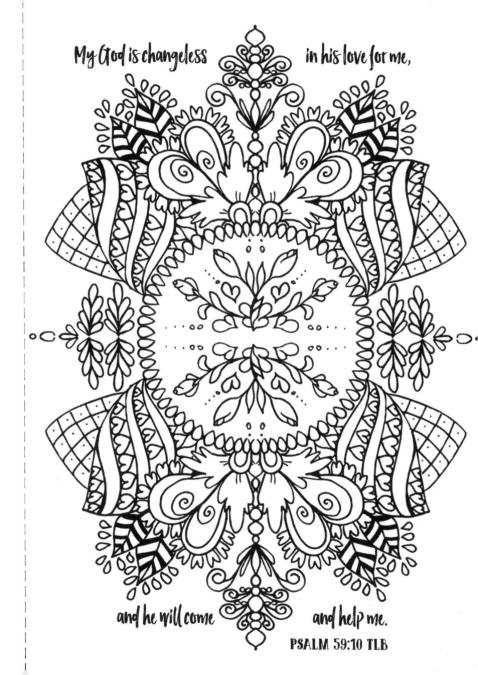

My God is changeless in his love for me, and he will come and help me.

PSALM 59:10 TLB

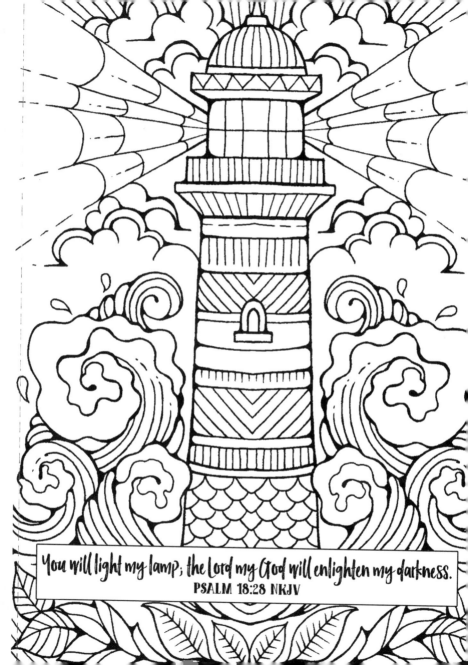

You will light my lamp; the Lord my God will enlighten my darkness.
PSALM 18:28 NKJV

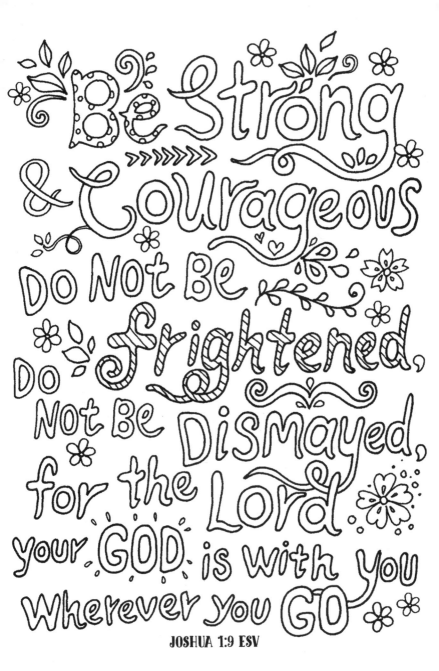

Be Strong & Courageous Do Not Be Frightened, Not Be Dismayed, for the Lord your GOD is with you Wherever you GO

JOSHUA 1:9 ESV

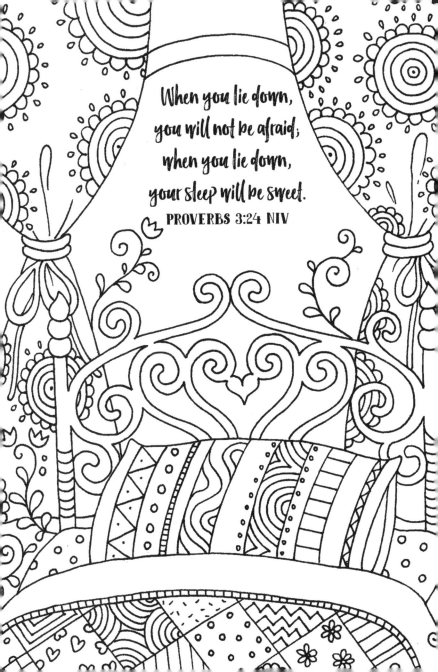

When you lie down,
you will not be afraid;
when you lie down,
your sleep will be sweet.
PROVERBS 3:24 NIV

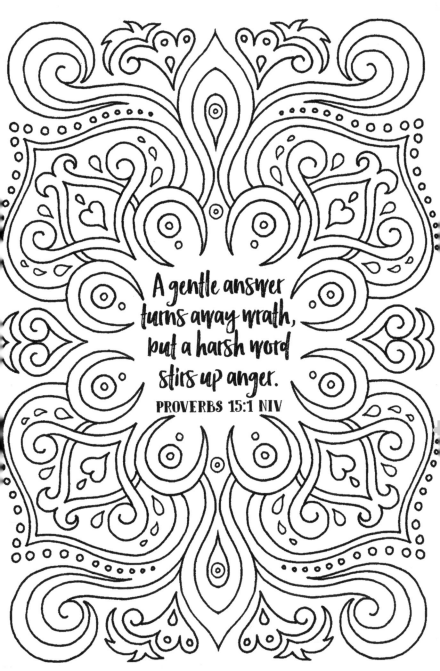

A gentle answer
turns away wrath,
but a harsh word
stirs up anger.
PROVERBS 15:1 NIV

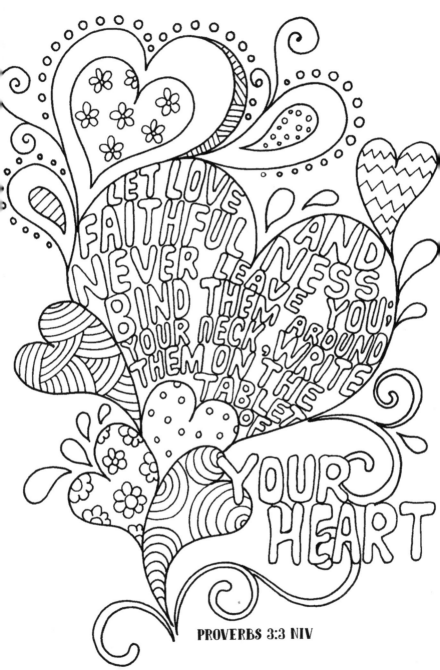

LET LOVE FAITHFULNESS AND NEVER LEAVE YOU; BIND THEM AROUND YOUR NECK, WRITE THEM ON THE TABLET OF

YOUR HEART

PROVERBS 3:3 NIV

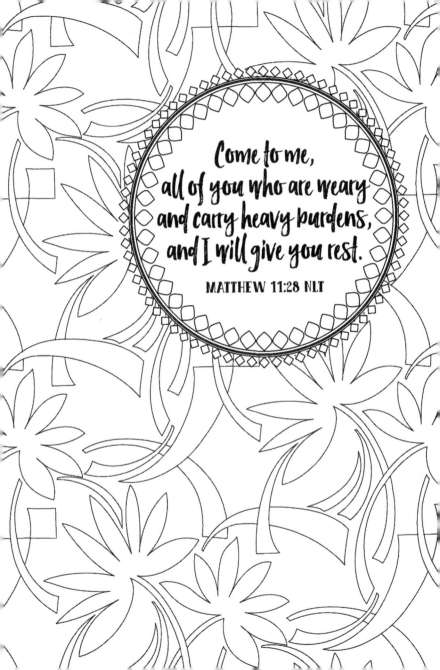

You, O Lord, are a shield about me,
My glory, and the One
who lifts my head.

PSALM 3:3 NASB

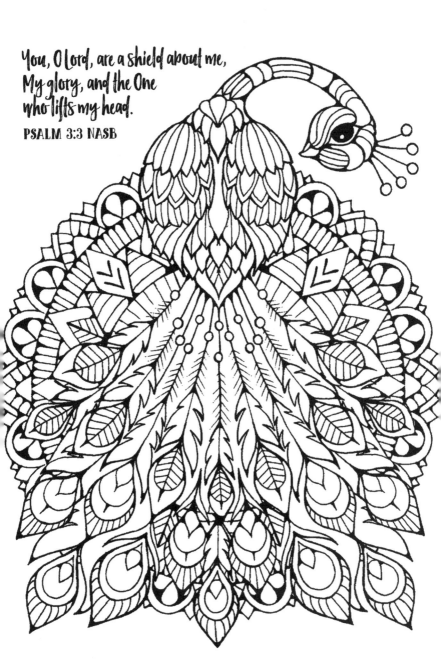

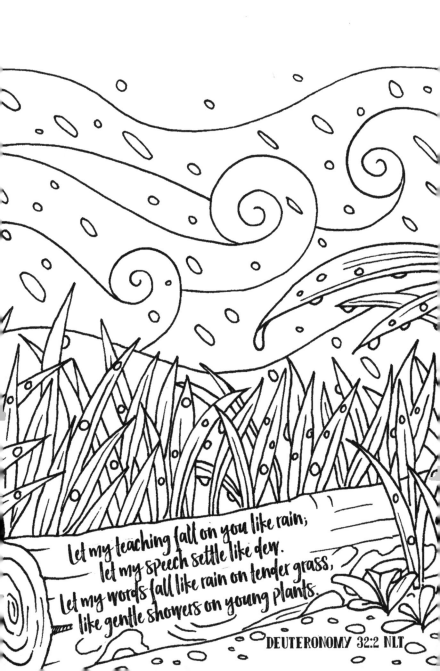

Let my teaching fall on you like rain;
let my speech settle like dew.
Let my words fall like rain on tender grass,
like gentle showers on young plants.

DEUTERONOMY 32:2 NLT

THREE THINGS
WILL LAST FOREVER —
FAITH, HOPE, AND LOVE
— AND THE GREATEST
OF THESE
IS LOVE.

1 CORINTHIANS 13:13 NLT

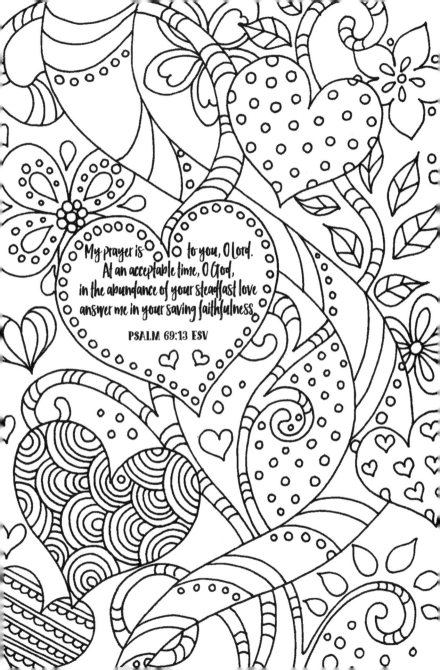

My prayer is to you, O Lord.
At an acceptable time, O God,
in the abundance of your steadfast love
answer me in your saving faithfulness.

PSALM 69:13 ESV

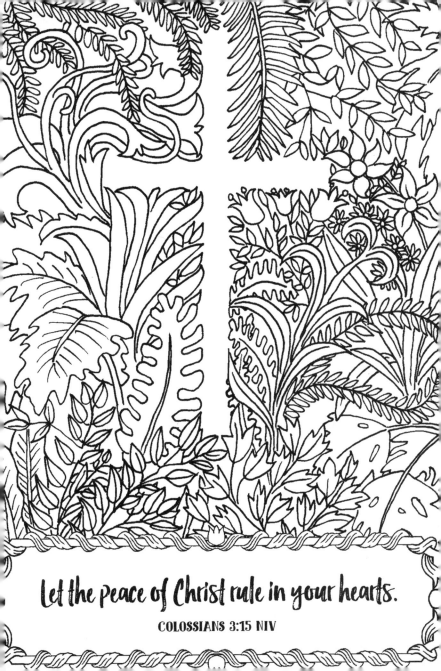

Let the peace of Christ rule in your hearts.

COLOSSIANS 3:15 NIV

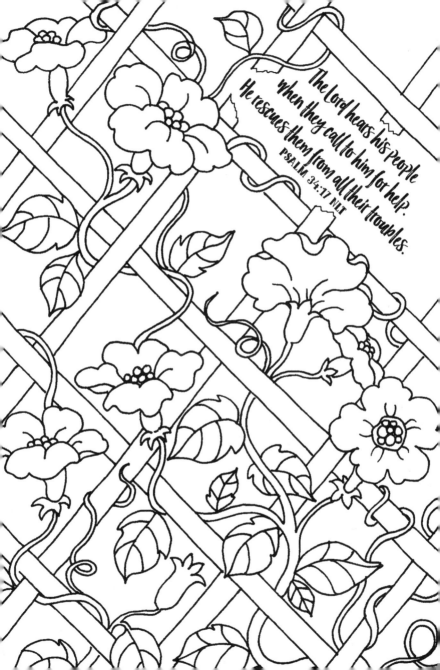

The Lord hears his people when they call to him for help. He rescues them from all their troubles. PSALM 34:17 NLT

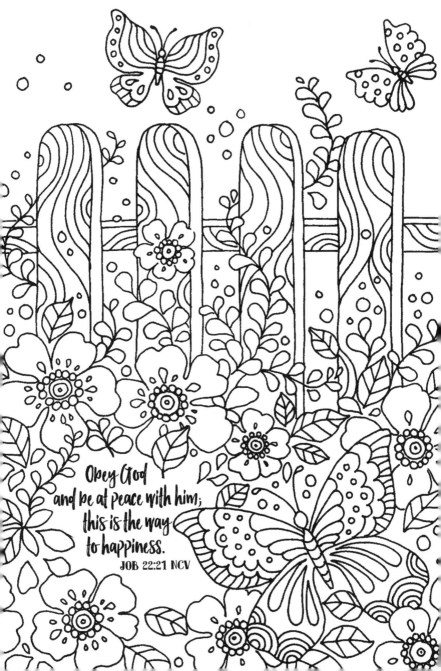

Obey God
and be at peace with him;
this is the way
to happiness.

JOB 22:21 NCV

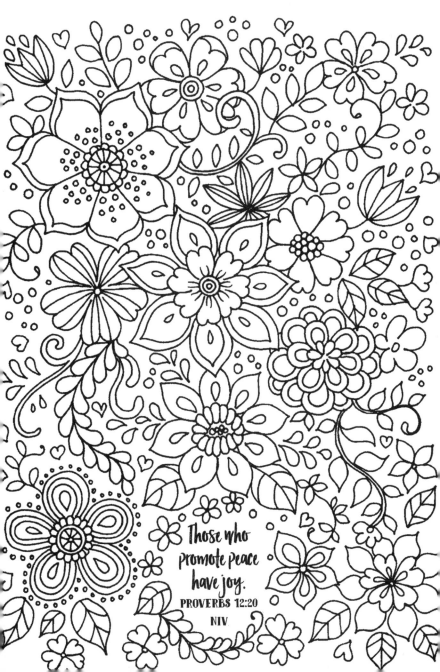

Those who
promote peace
have joy.
PROVERBS 12:20
NIV

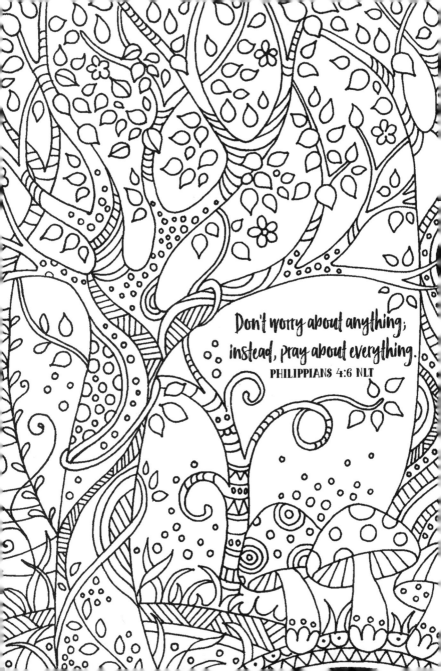

Don't worry about anything;
instead, pray about everything.
PHILIPPIANS 4:6 NLT

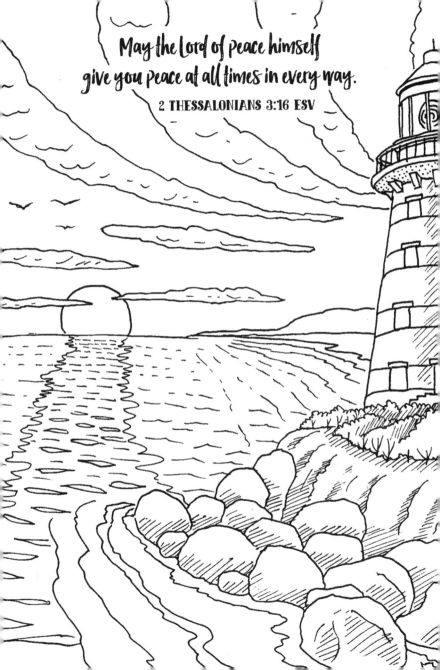

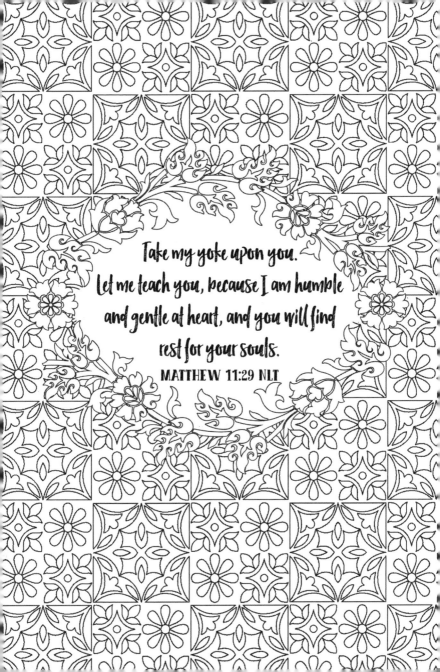

Take my yoke upon you.
Let me teach you, because I am humble
and gentle at heart, and you will find
rest for your souls.

MATTHEW 11:29 NLT

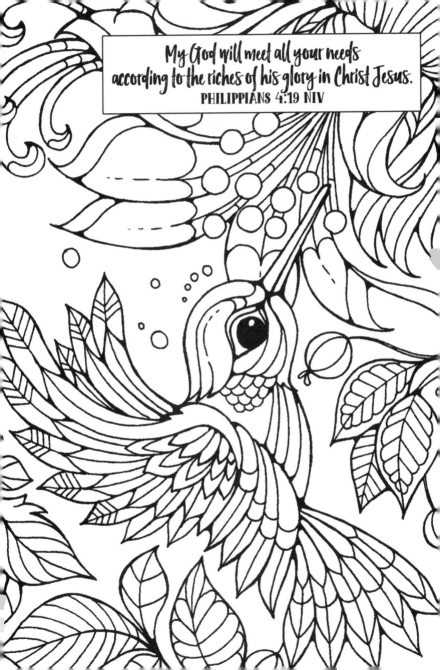

My God will meet all your needs according to the riches of his glory in Christ Jesus.
PHILIPPIANS 4:19 NIV

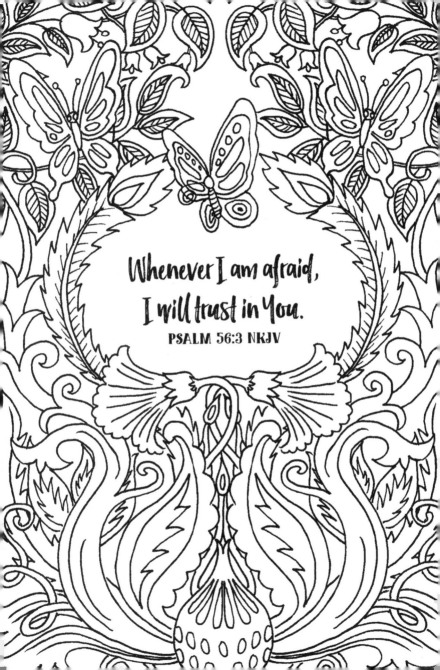

Whenever I am afraid,
I will trust in You.

PSALM 56:3 NKJV

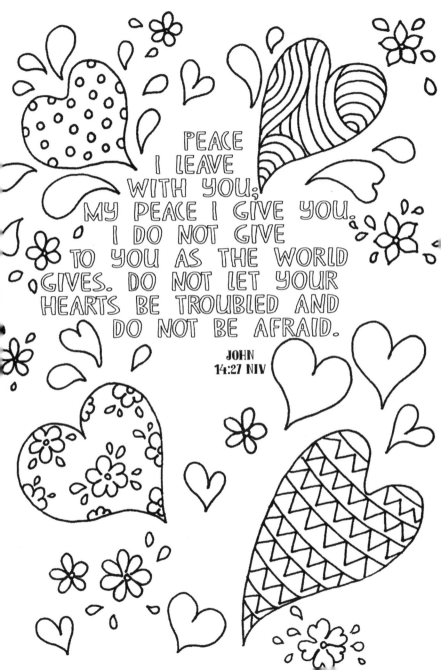

PEACE
I LEAVE
WITH YOU;
MY PEACE I GIVE YOU.
I DO NOT GIVE
TO YOU AS THE WORLD
GIVES. DO NOT LET YOUR
HEARTS BE TROUBLED AND
DO NOT BE AFRAID.

JOHN
14:27 NIV

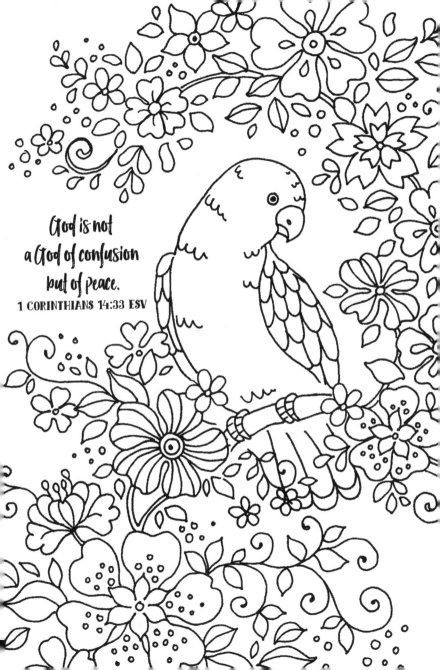

God is not
a God of confusion
but of peace.
1 CORINTHIANS 14:33 ESV

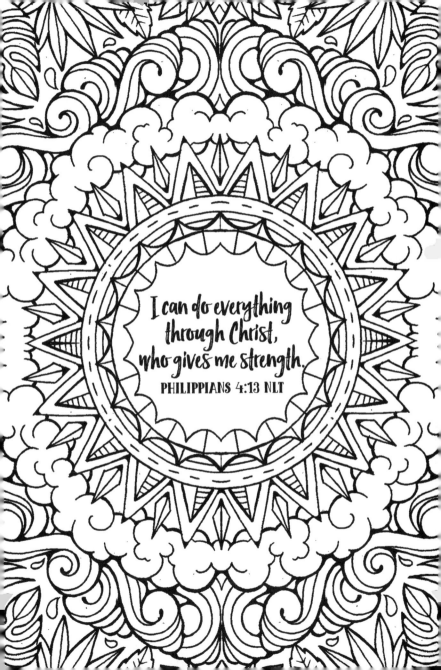

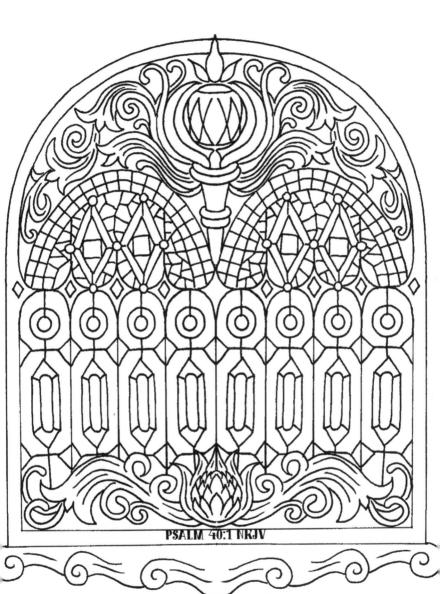

PSALM 40:1 NKJV

I waited patiently for the Lord;
And He inclined to me, and heard my cry.

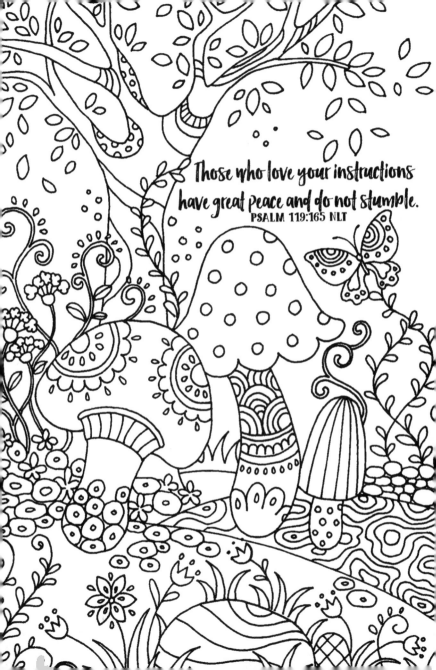

Those who love your instructions have great peace and do not stumble.

PSALM 119:165 NLT

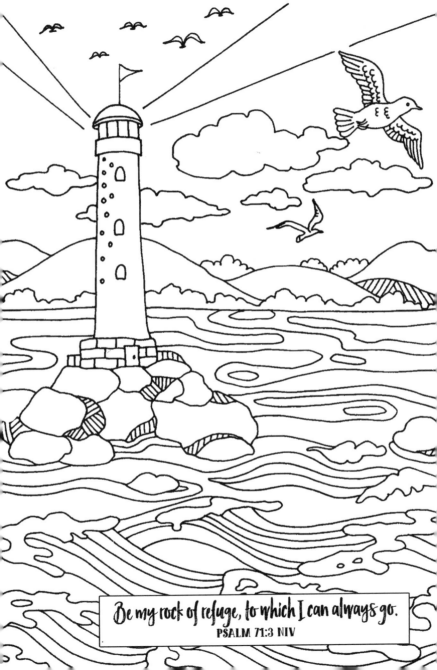

Be my rock of refuge, to which I can always go.
PSALM 71:3 NIV

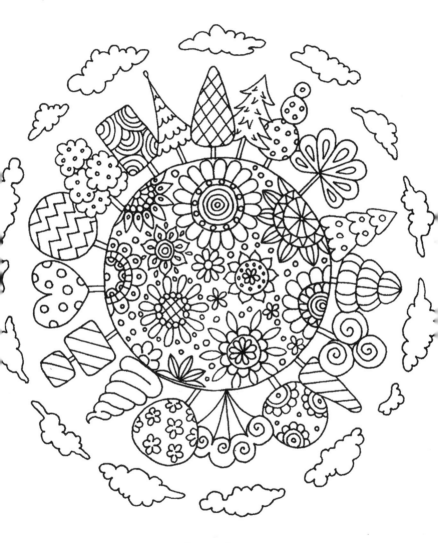

God blesses those who work for peace,
for they will be called the children of God.
MATTHEW 5:9 NLT

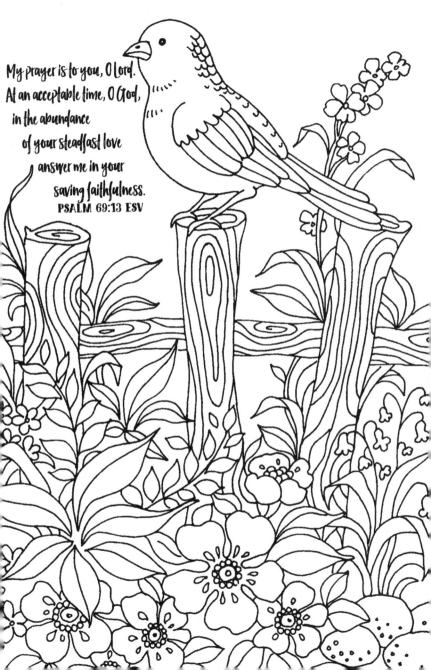

My prayer is to you, O Lord.
At an acceptable time, O God,
in the abundance
of your steadfast love
answer me in your
saving faithfulness.
PSALM 69:13 ESV